Coloring Book
For
Stress Relieving

FLOWER DESIGN

By..

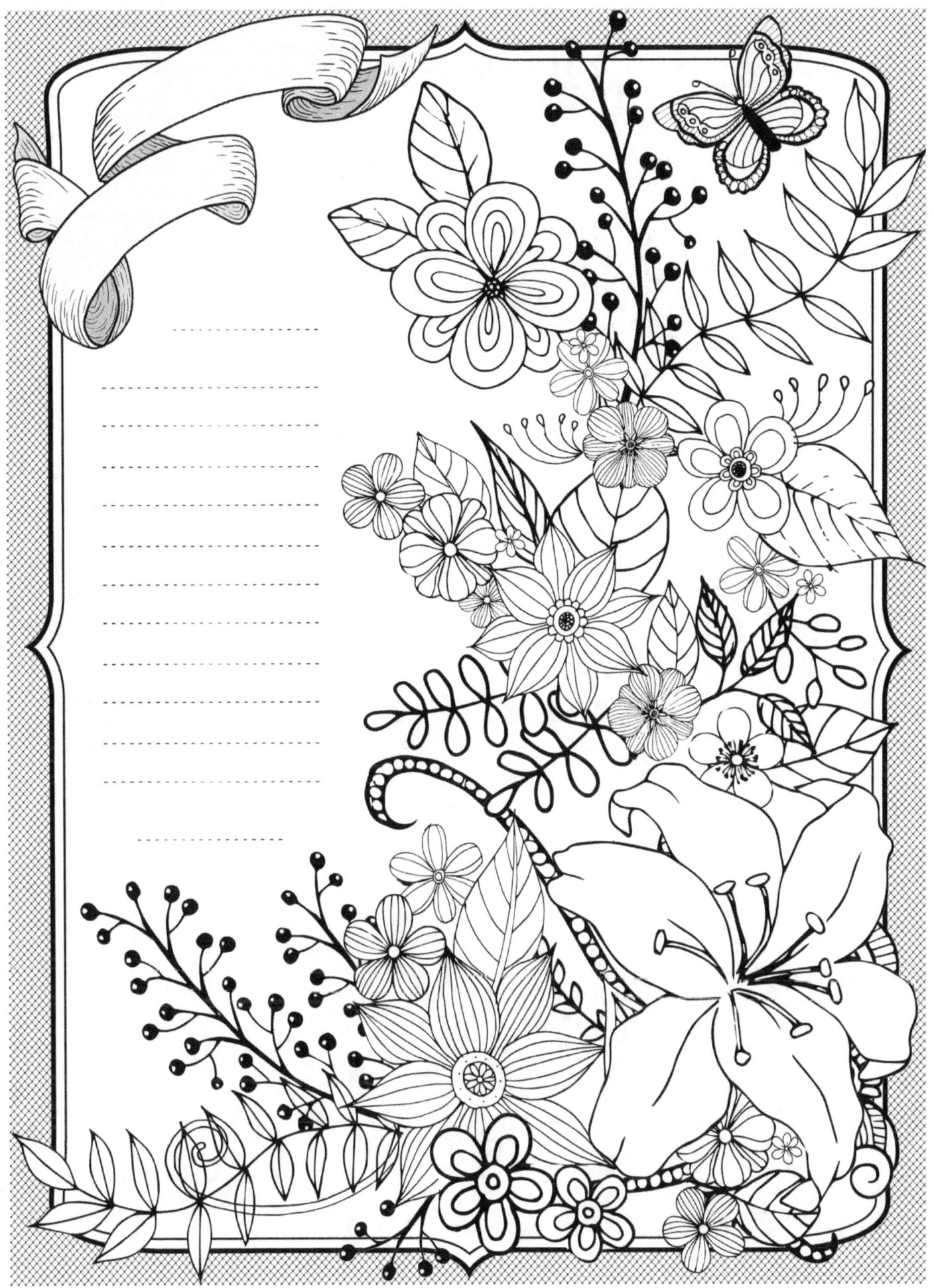

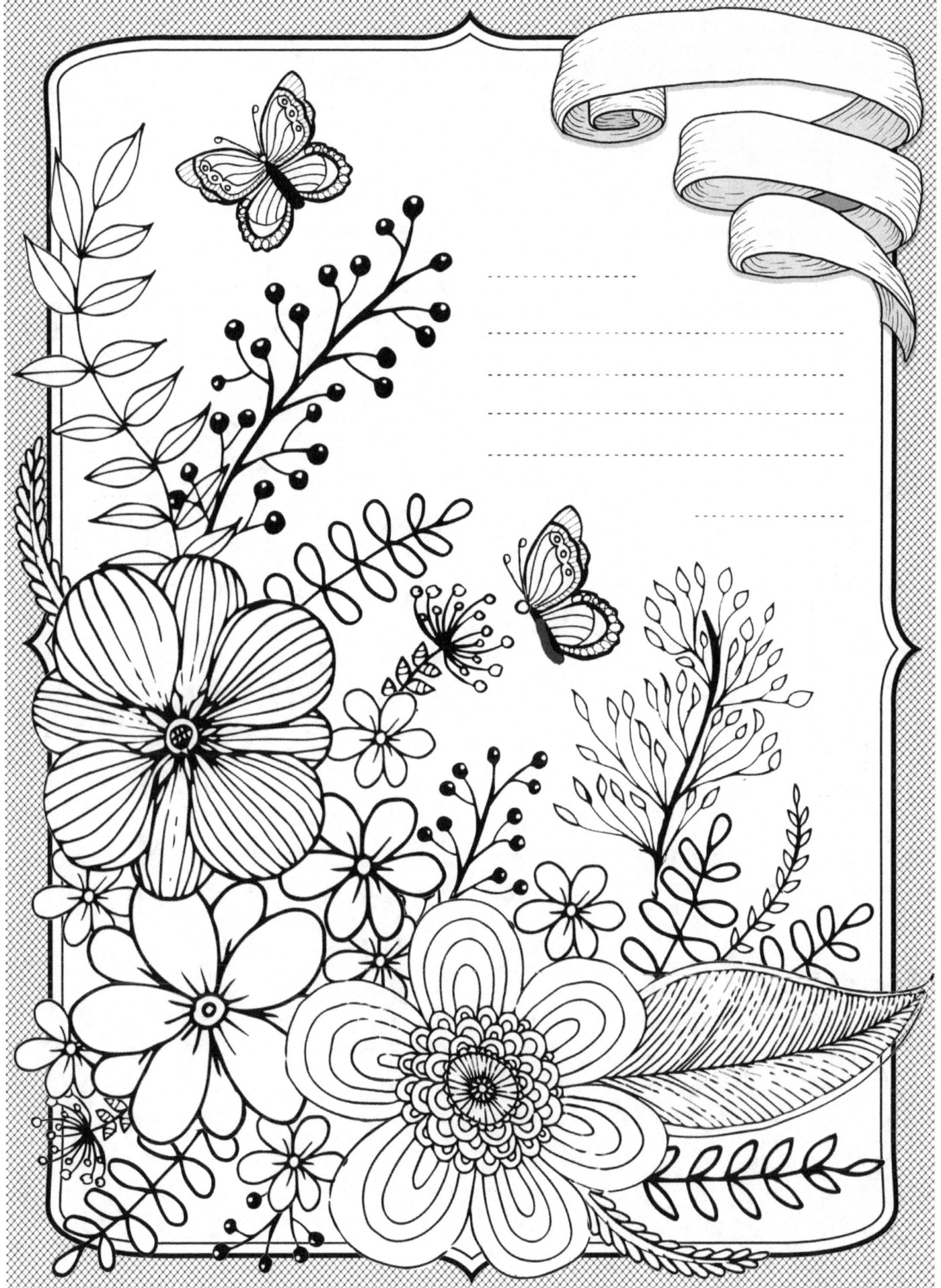

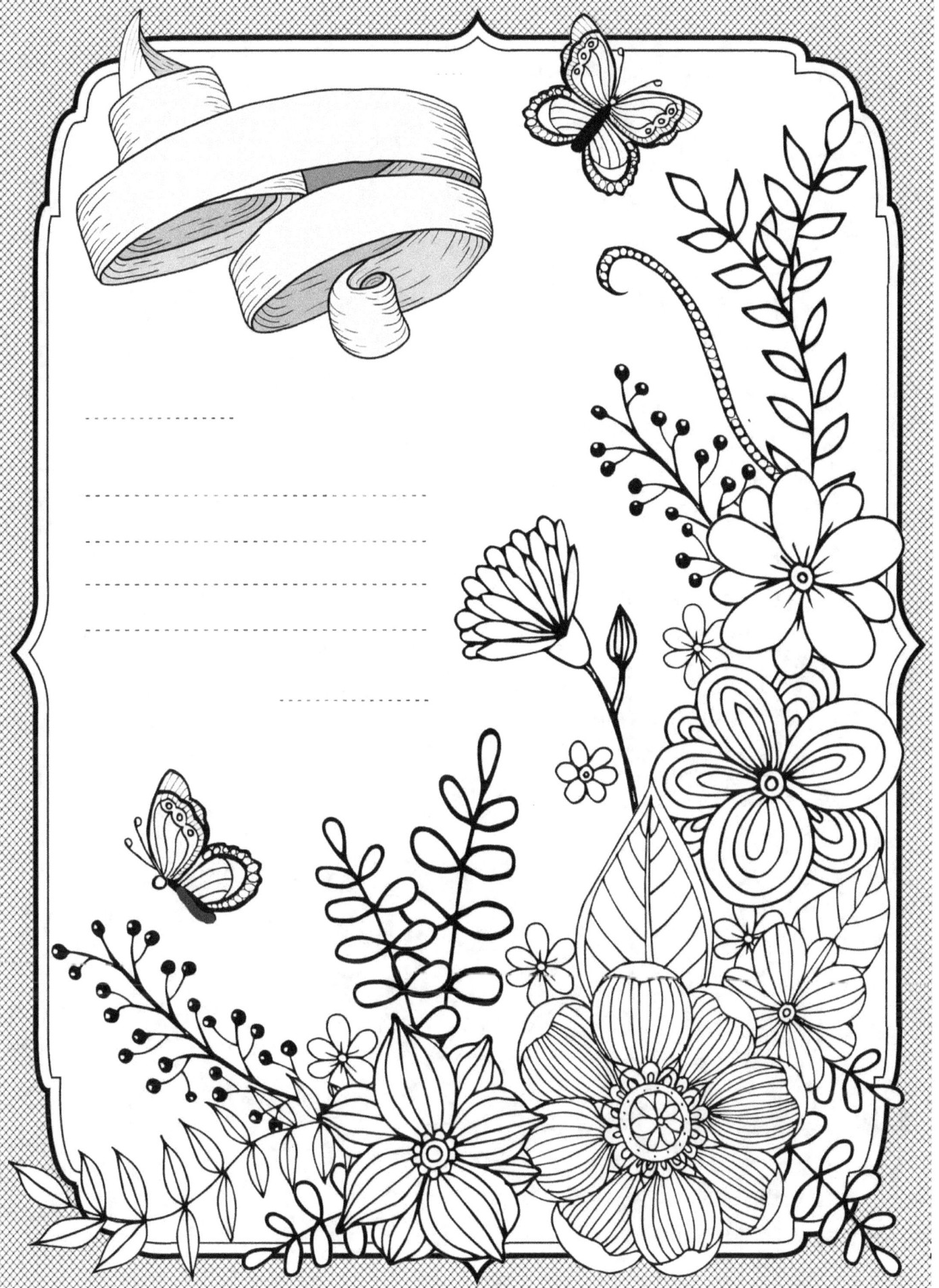

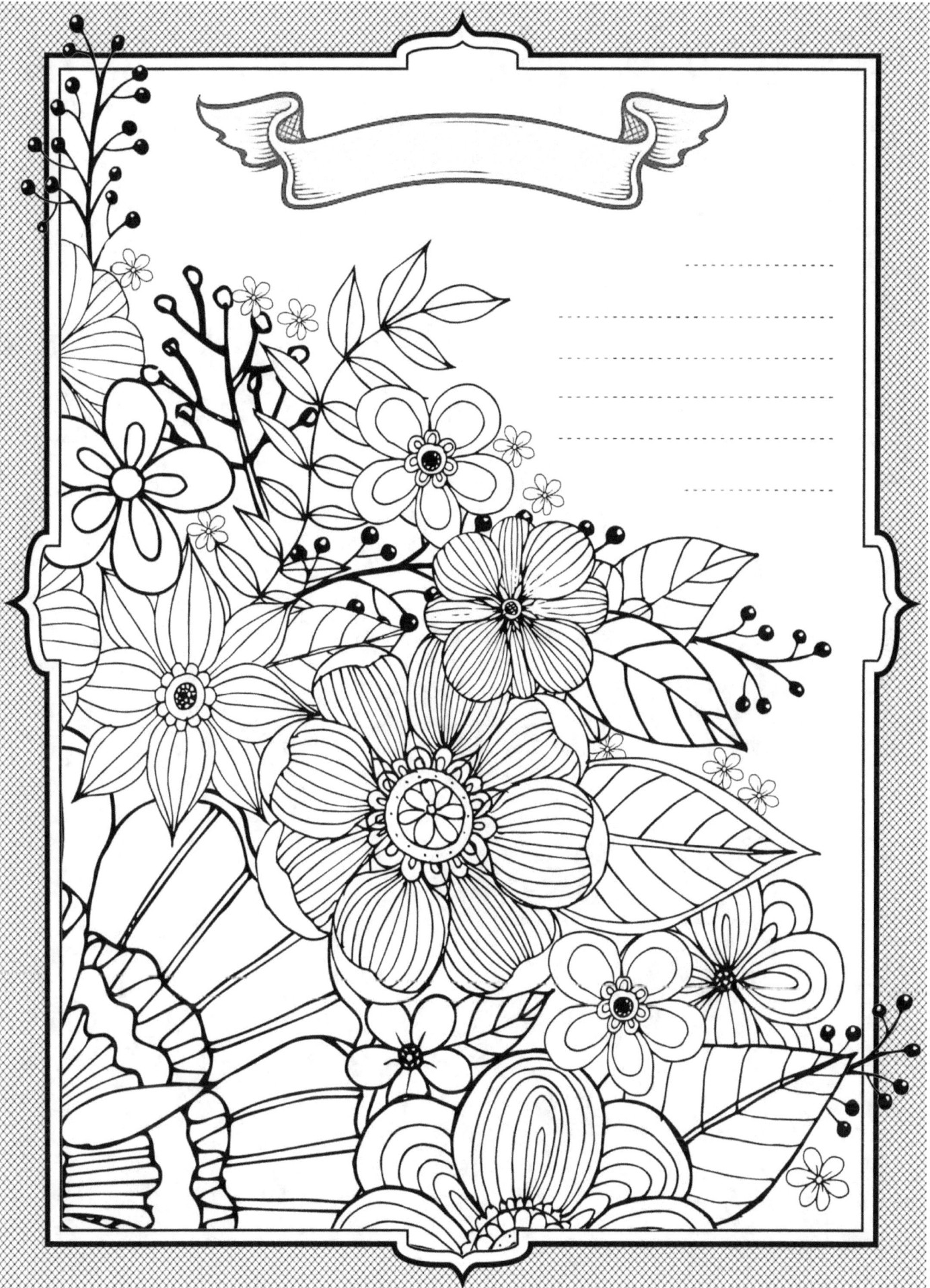

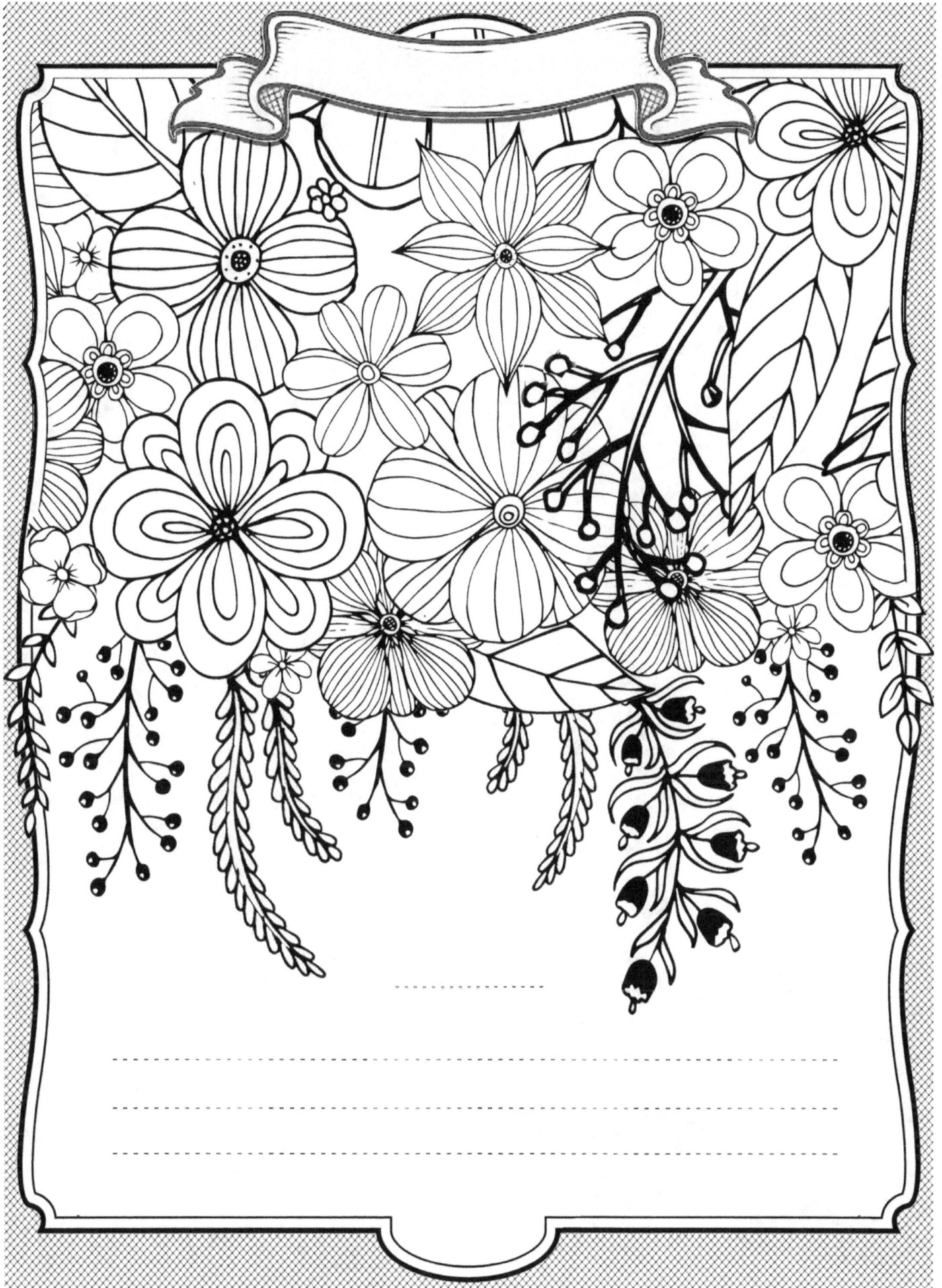

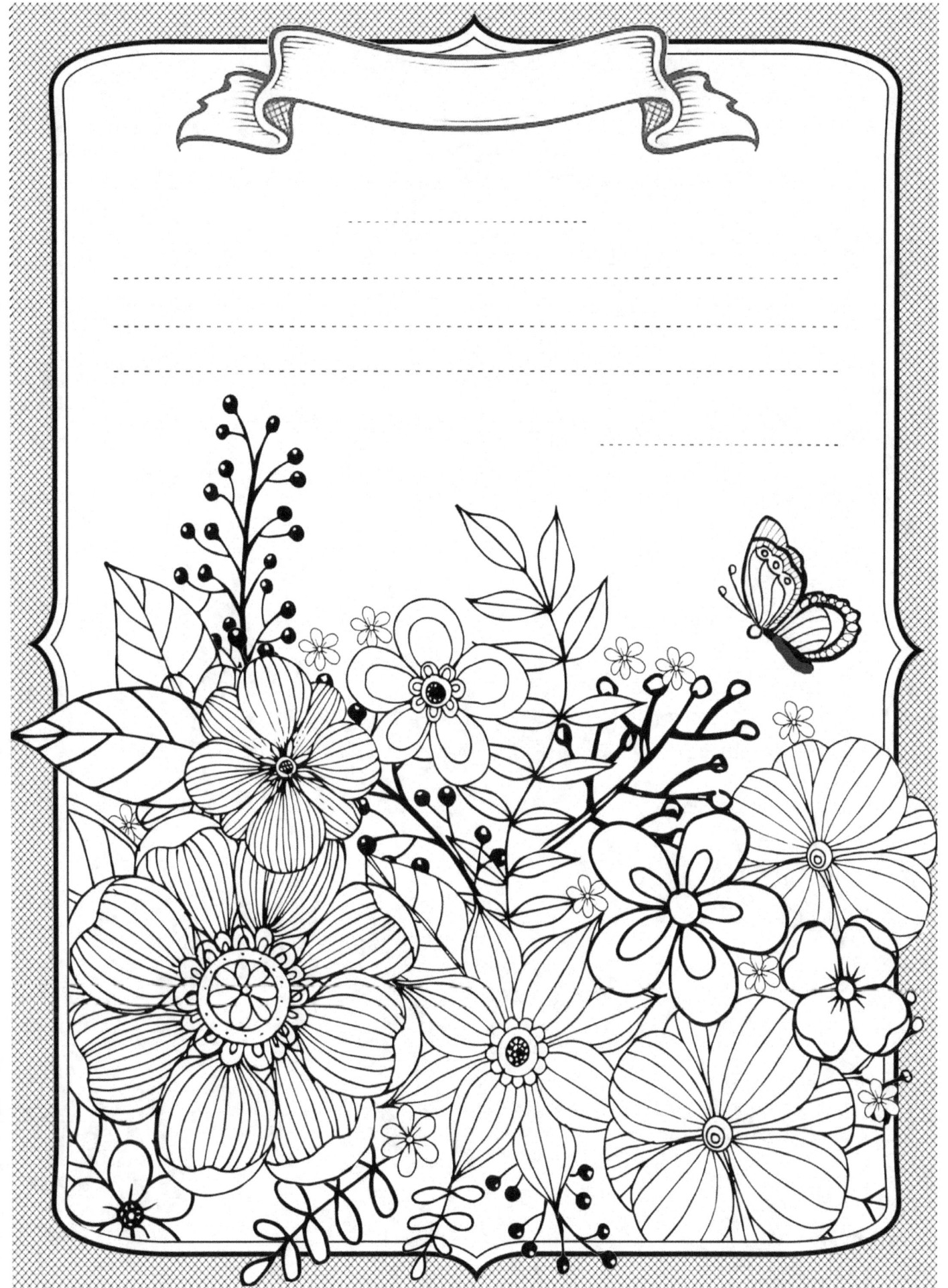

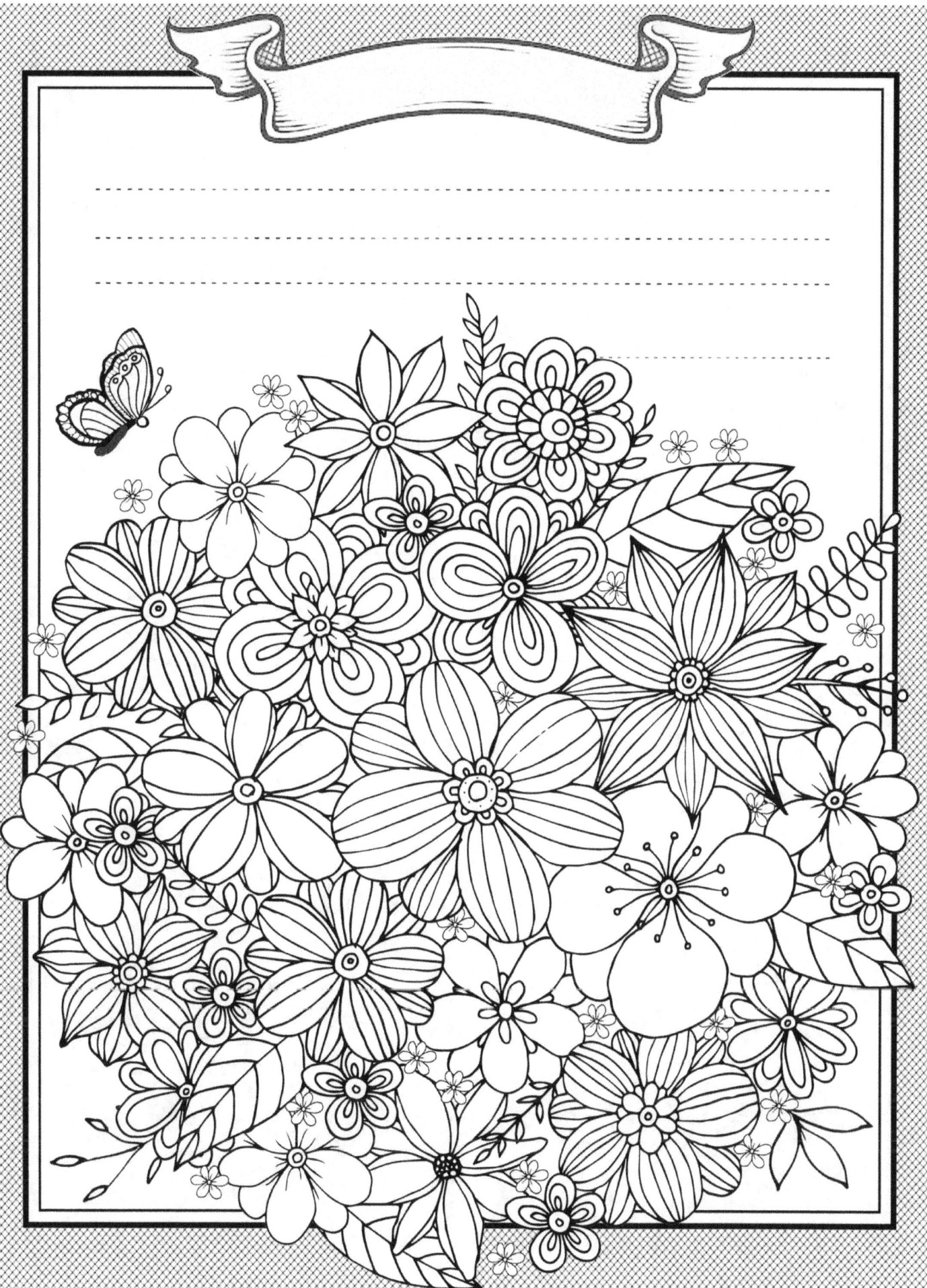

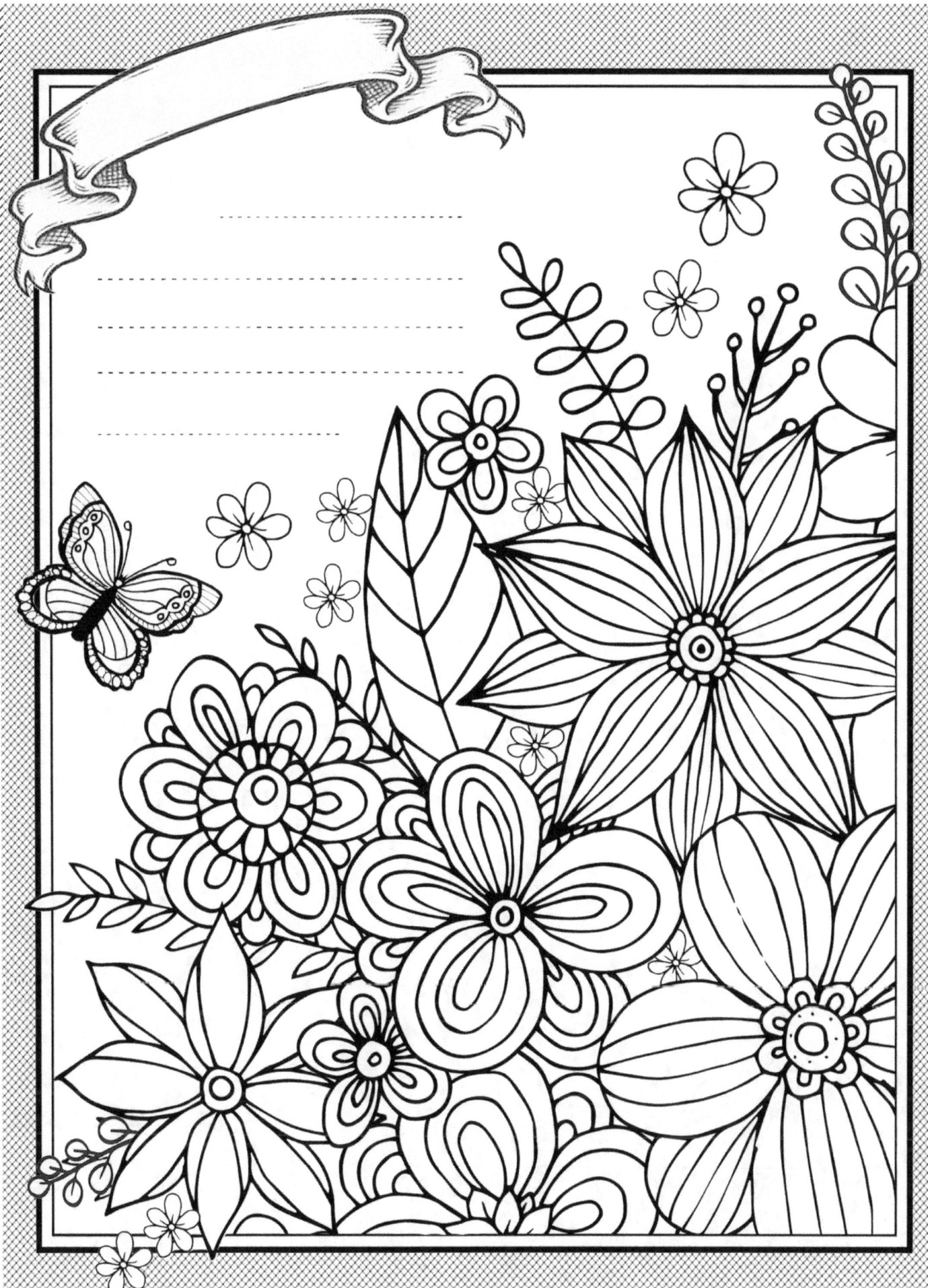

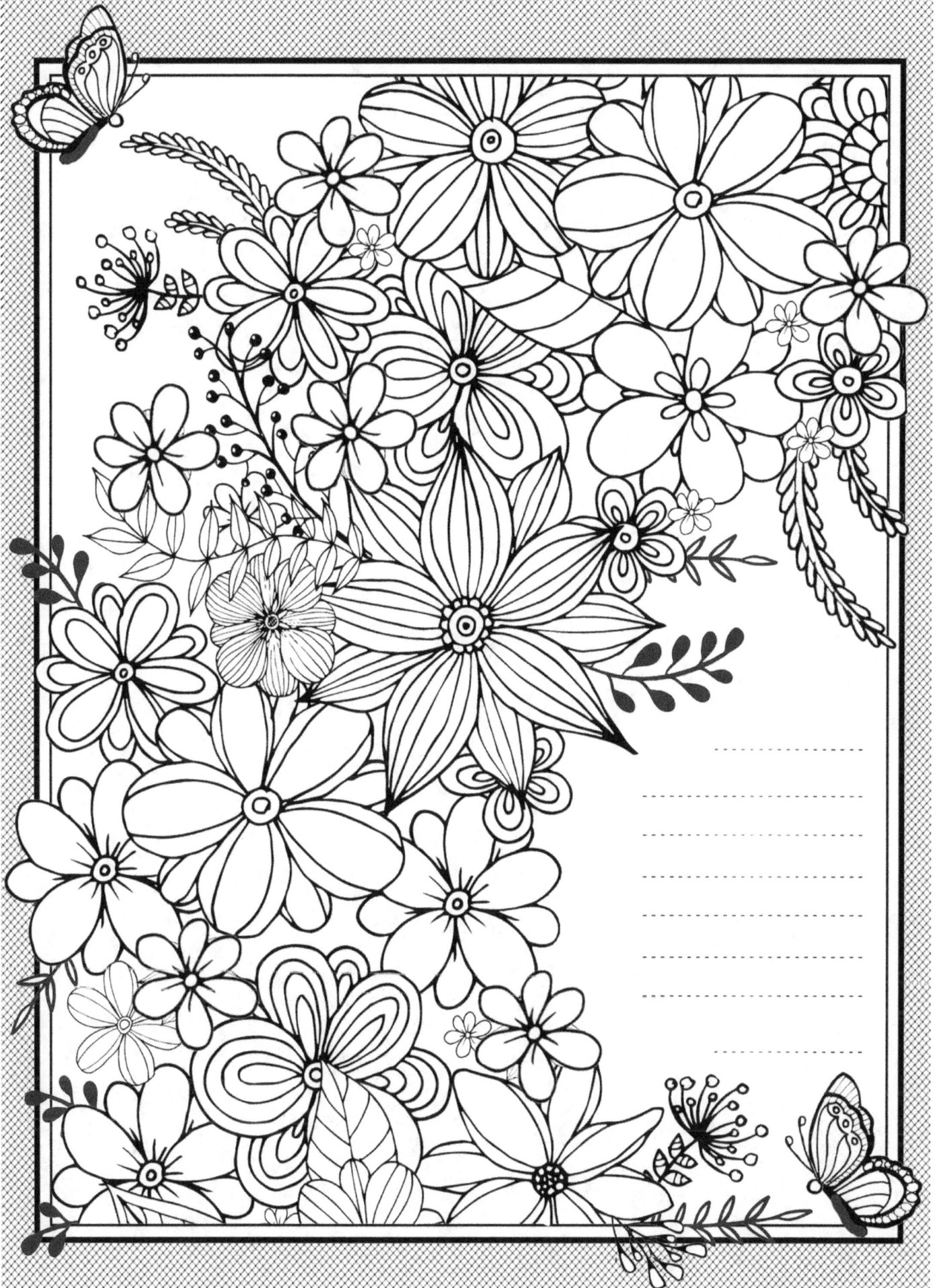

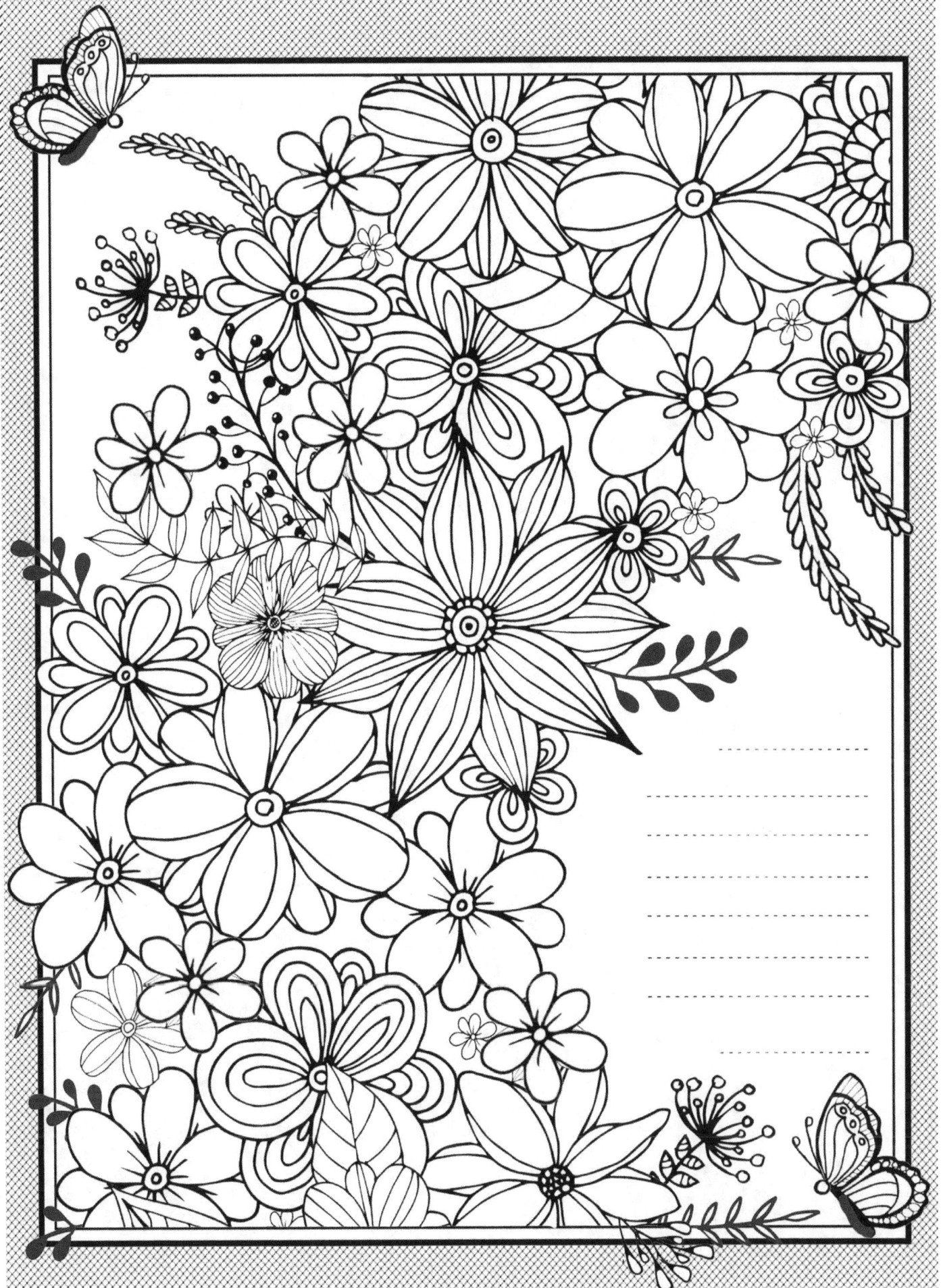

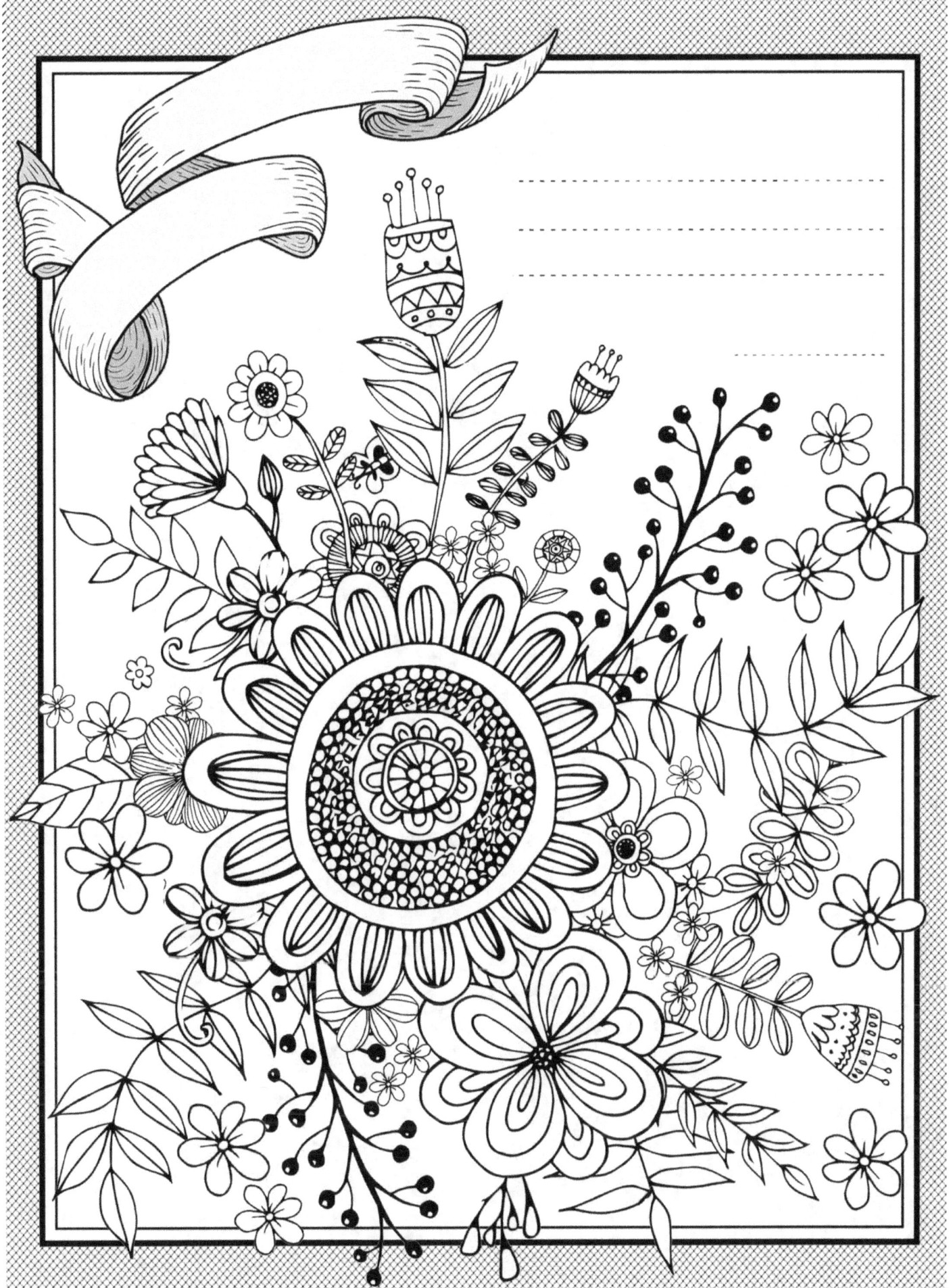

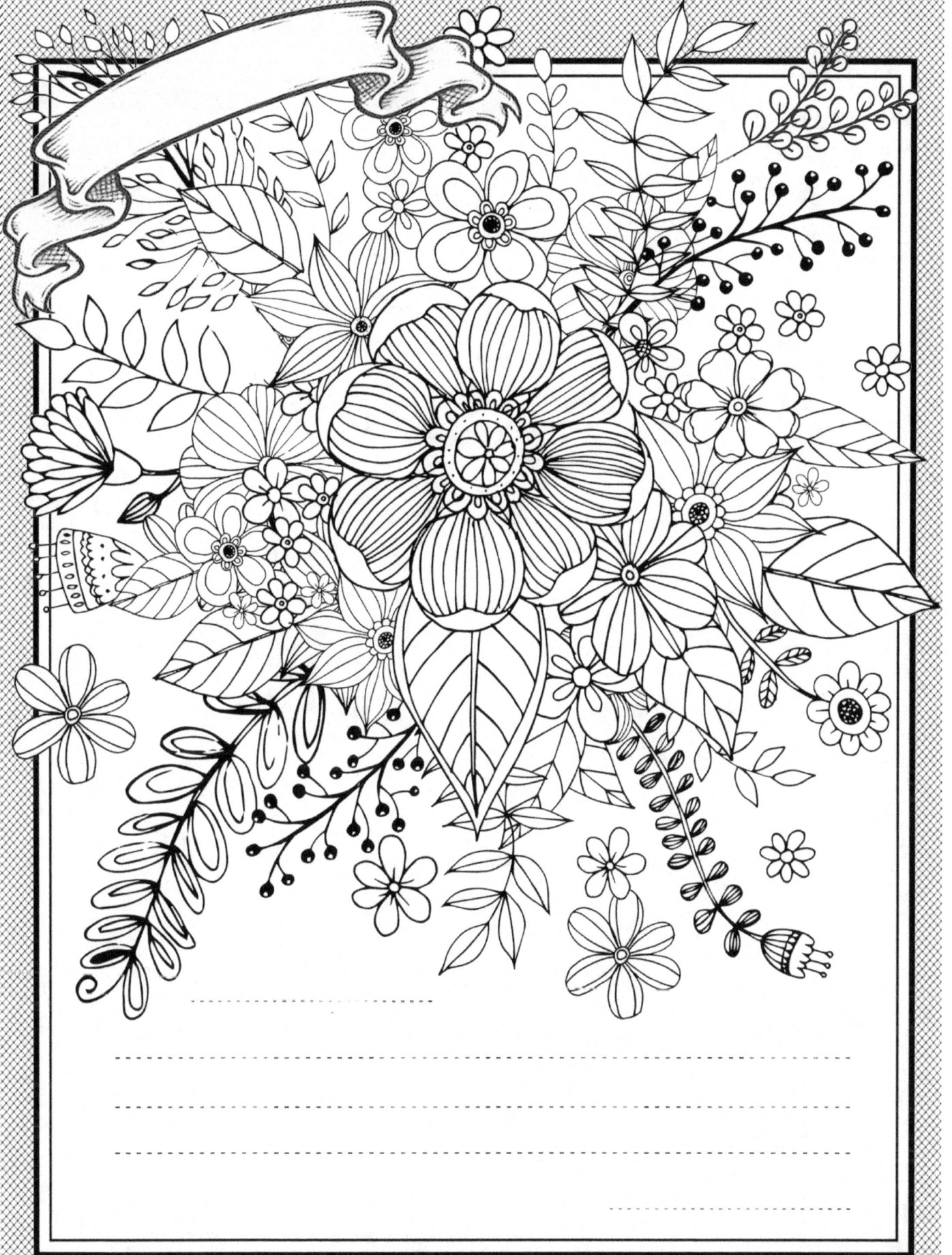

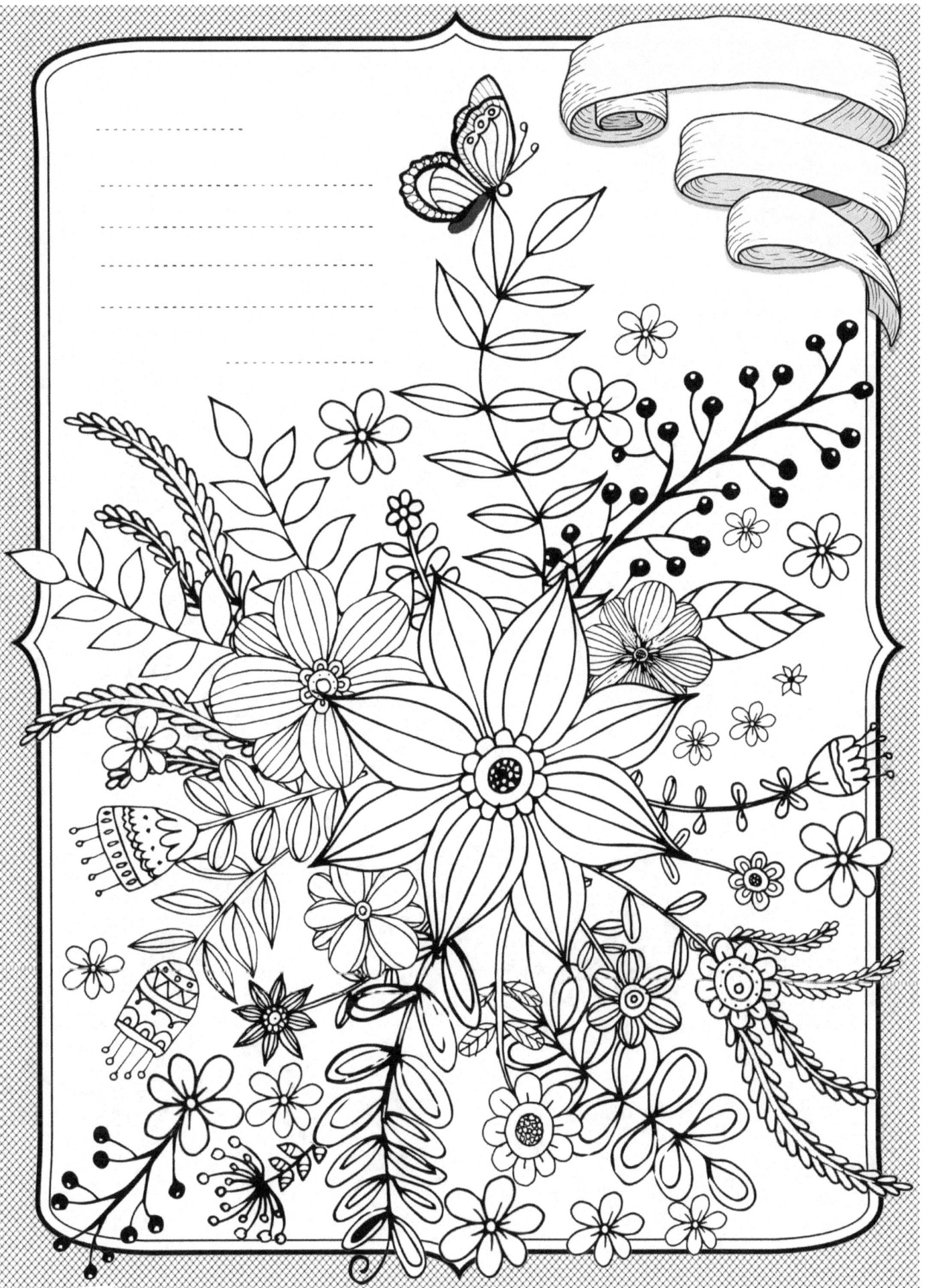

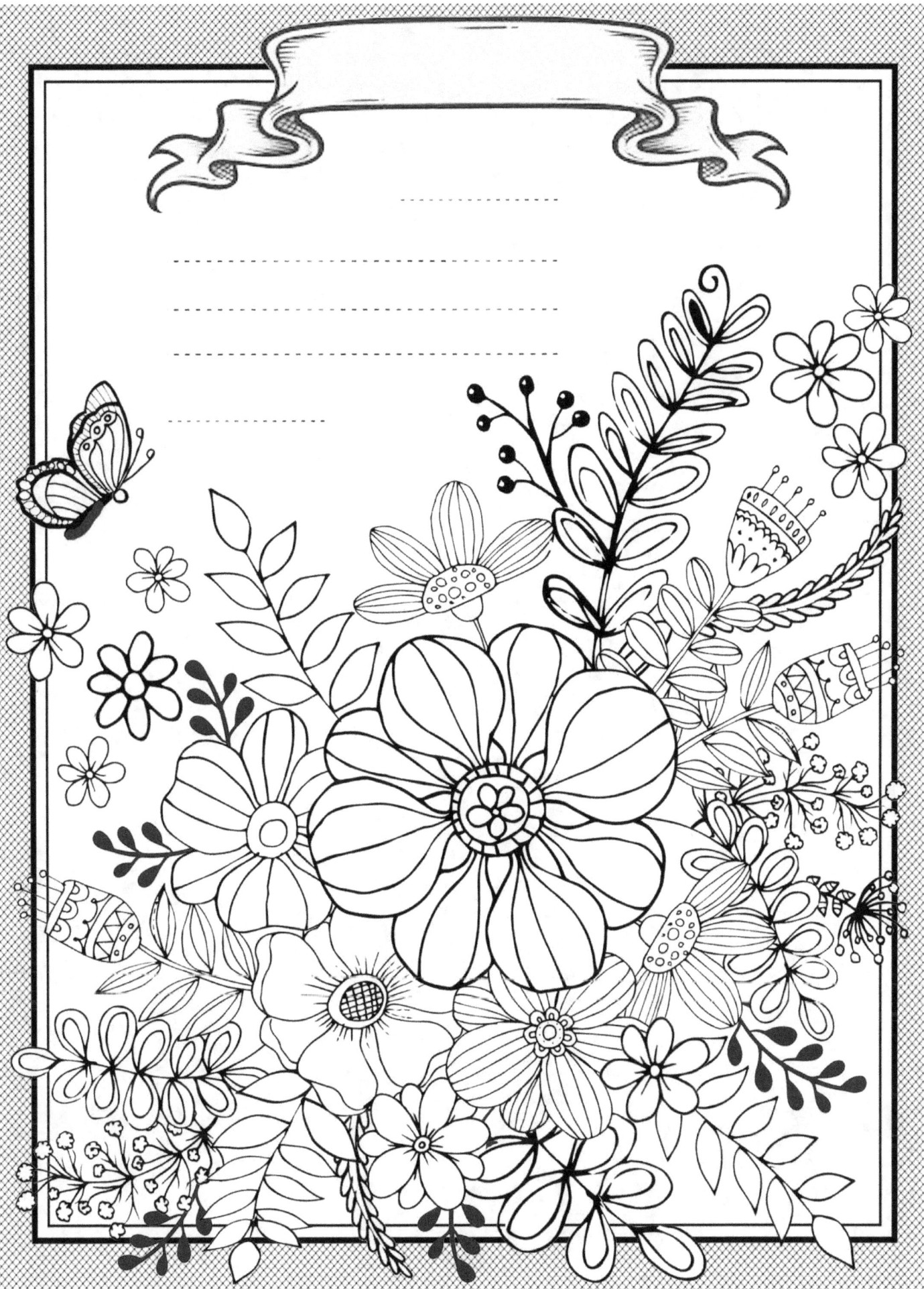

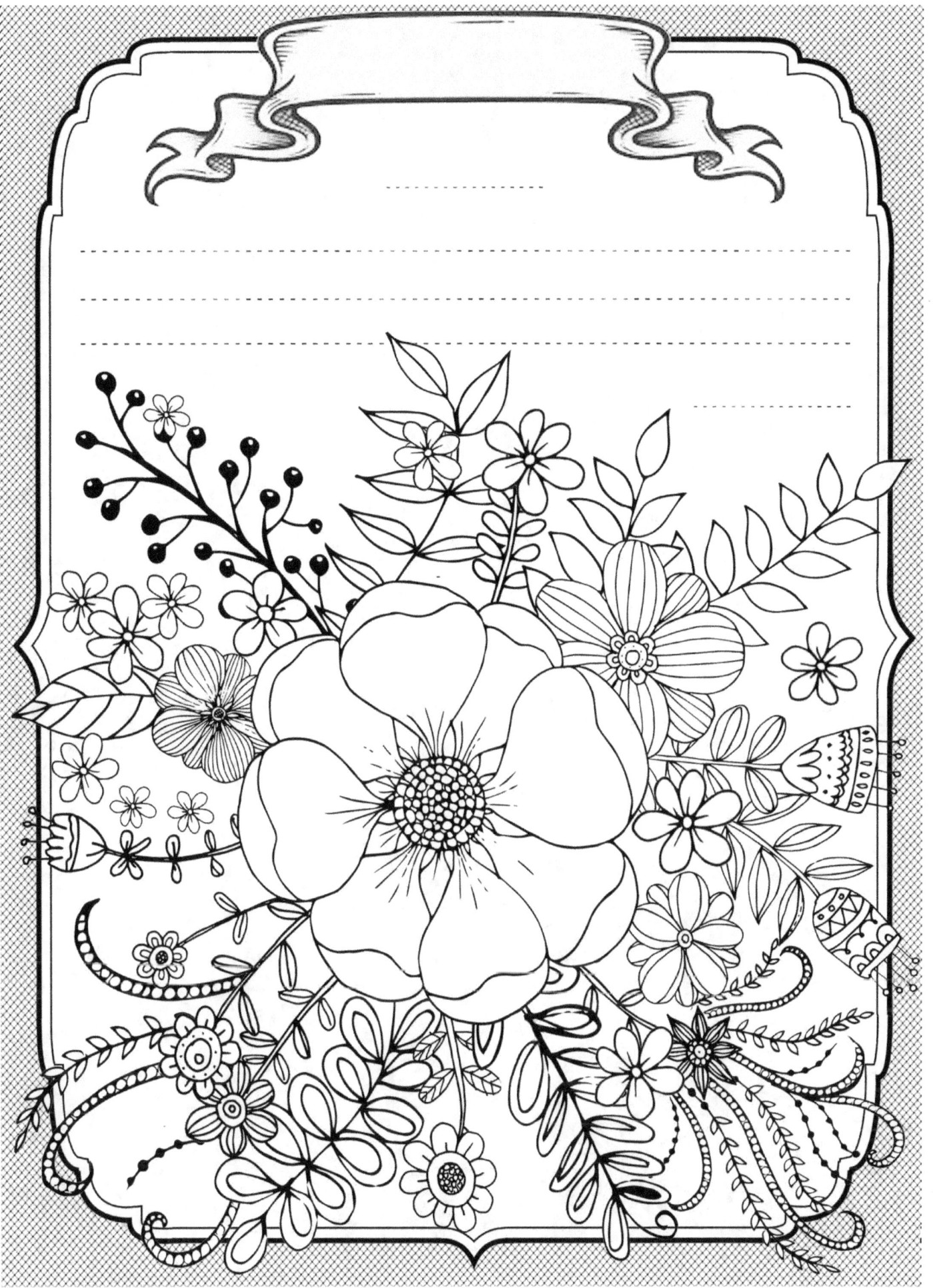

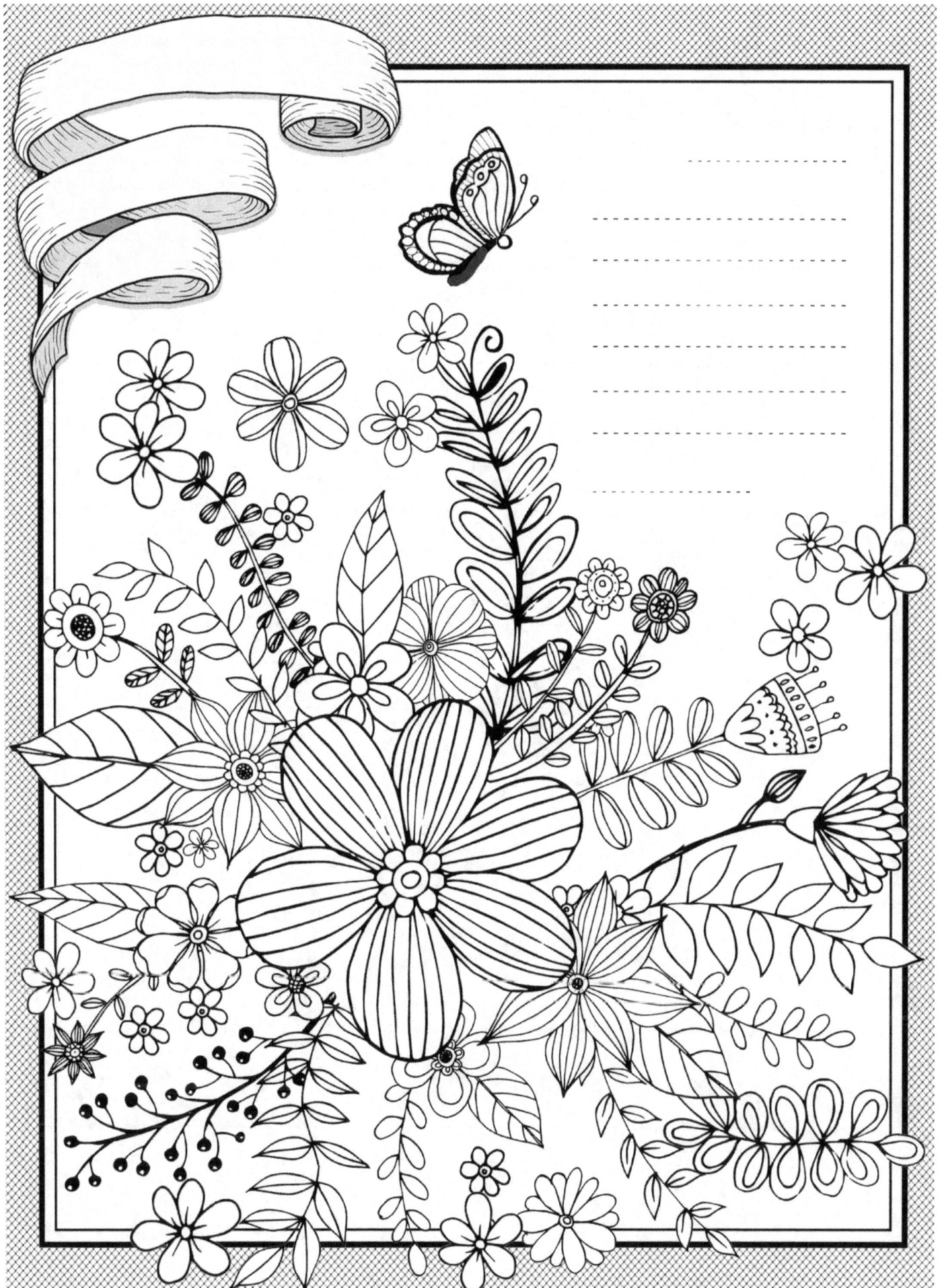

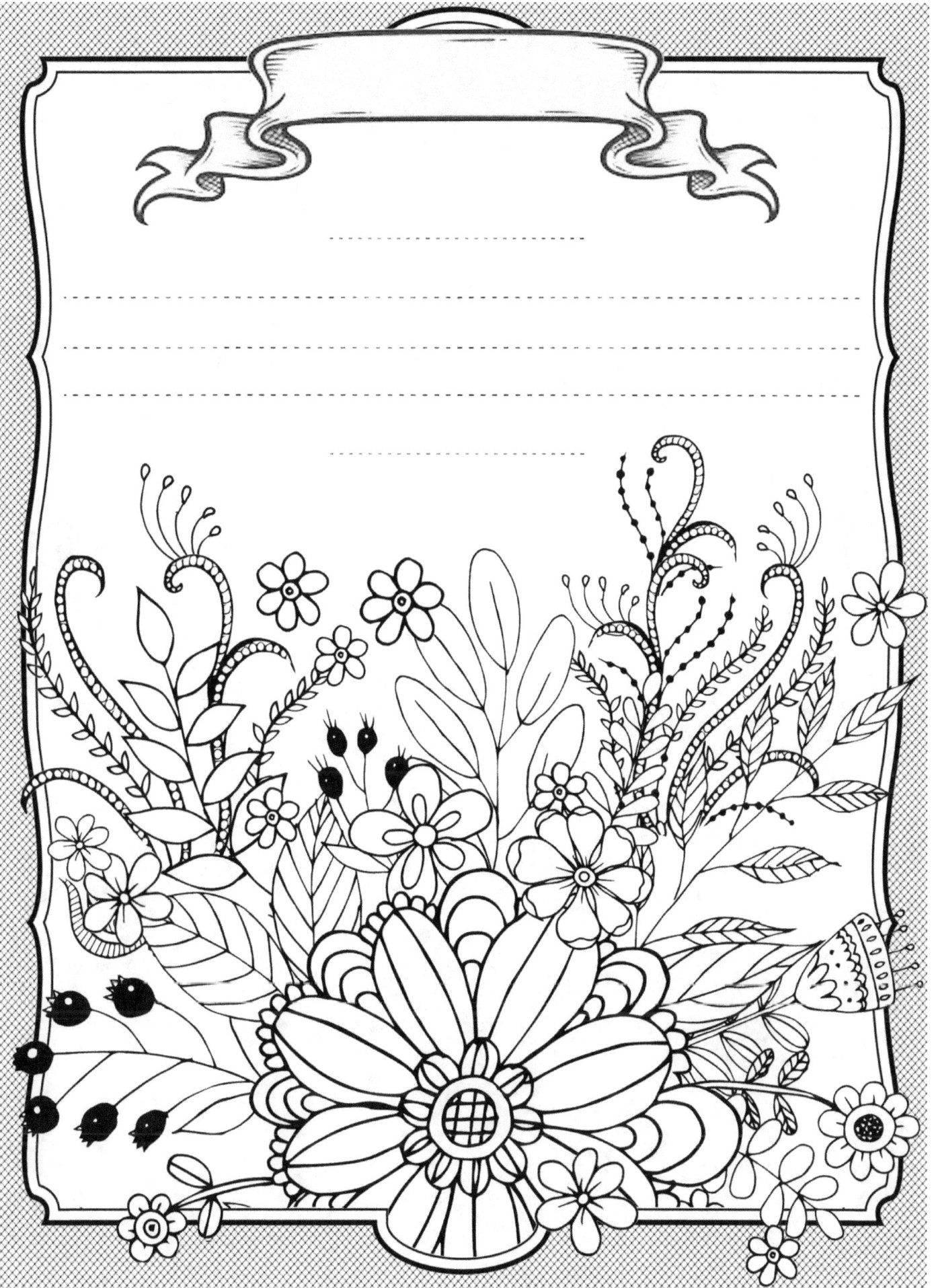

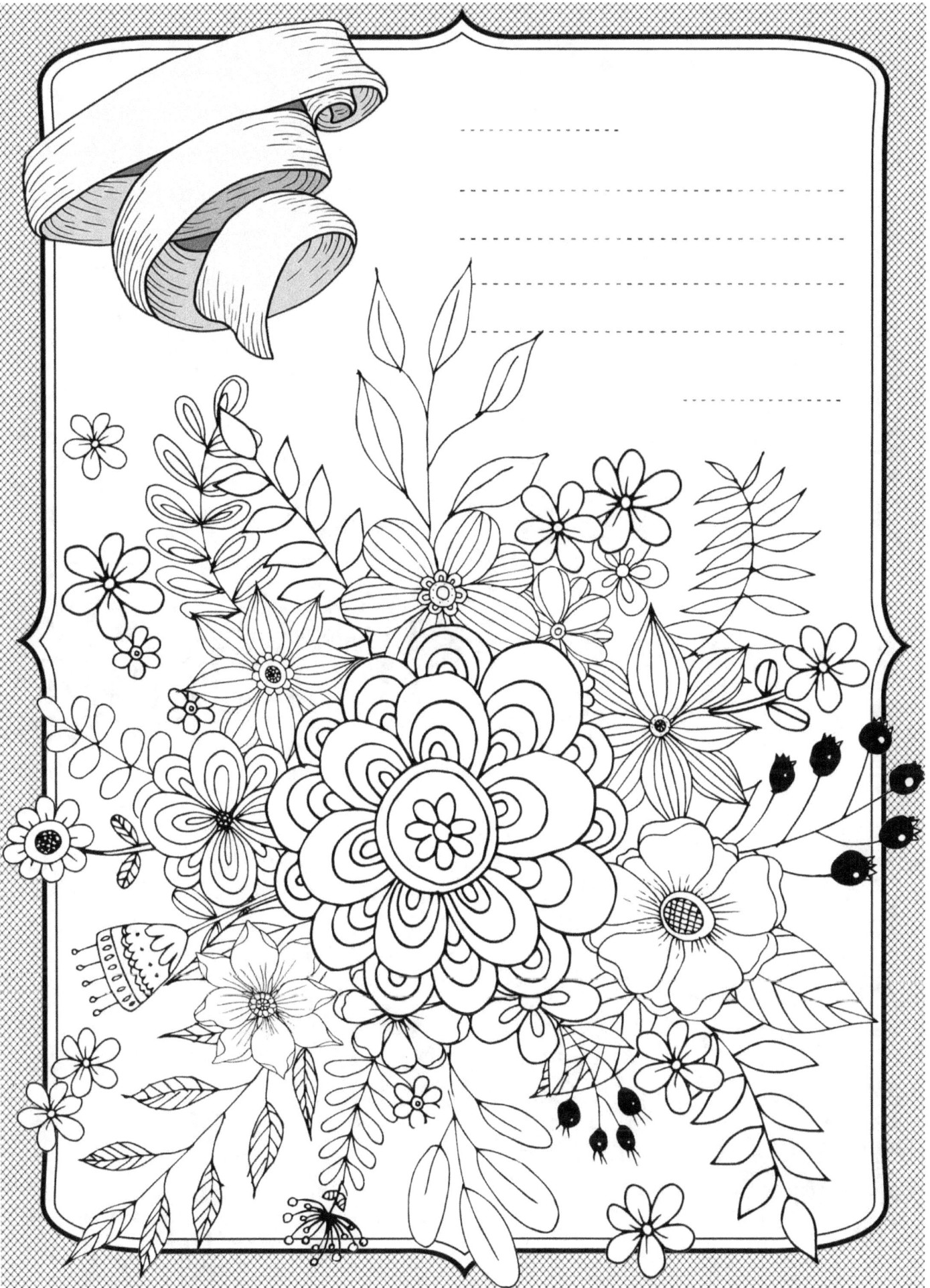

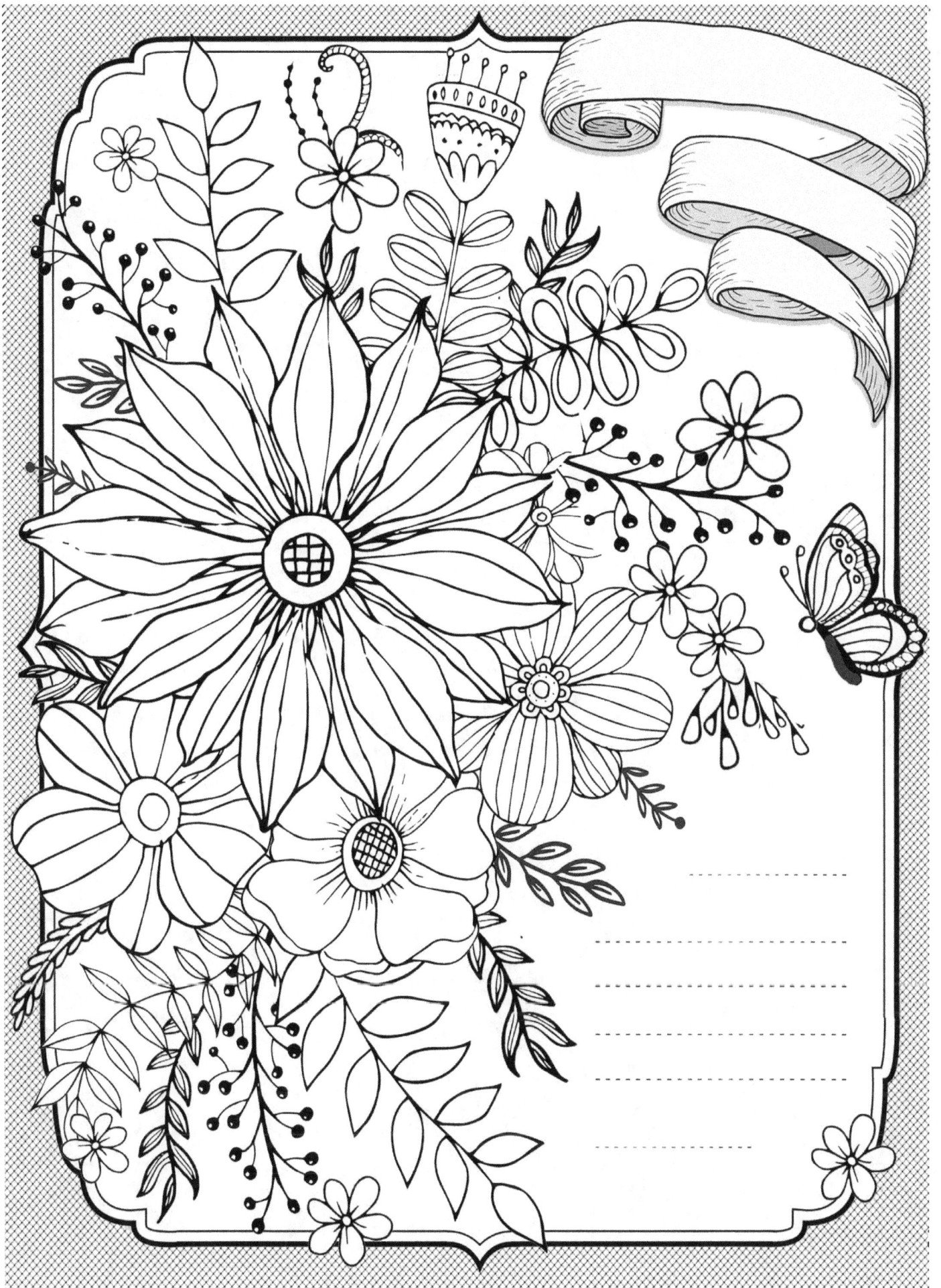

www.ingramcontent.com/pod-product-compliance
Lightning Source LLC
Chambersburg PA
CBHW080848170526
45158CB00009B/2670